The Best Collection of Vintage and Modern Images for Adults to Colour

Clara Brown

Copyright © Clara Brown 2017

All Rights Reserved

ISBN-13:
978-1545185711

ISBN-10:
1545185719

Are you stressed and struggling to relax?

Would you like a simple, easy way to feel calmer, free from daily worries and happier than you thought possible?

If so, The Best Collection of Vintage and Modern Images for Adults to Colour is the answer. This is the best colouring book for adults, a true art therapy colouring Book for grownups.

Just by colouring the images in this book you will become relaxed, calmer, happier and free of stress.

This colouring book for adults contains 40 new and original images for grownups who love to colour for relaxation.

Each image has been carefully created, to ensure your colouring experience is the best it can be.

As each picture that you colour reaches that secret side of your inner self you will let go of your anxieties, you will feel calmer and relaxed.

When we are relaxed and stress free we can cope with anything that life throws at us, when we are relaxed everyone we come in contact with benefits from that.

Many people, just like you, have found that colouring in these specially created images, can help you relax, making you calmer, happier and stress free.

These images are unique, and as you choose your colours and let your mind focus in on your colouring, you will find yourself taking a break from your daily worries.

You will find yourself relaxing and you have permission to let yourself relax and be happier in your daily life.

Research has shown that by taking some time each day, even for a few minutes, to relax, can have many benefits for your health, and can greatly improve your life.

The connection between art and hypnotic trance state is well known, and today we understand that colouring will allow you to leave your worries behind and enter into your own hypnotic state of trance.

We understand the meaning of Art Therapy and know it is used to alleviate both physical and anxiety based problems.

When we colour our minds are free to enter into a hypnotic trance, we go into a relaxed state as we concentrate on our colouring. In effect we are tapping into our inner selves and accessing that side of us that is creative, calmer, and stress free.

We can use our art to take time out of a busy stressful day, to calm our minds and bodies, this in turn makes us happier and healthier and recharges us to face our daily lives refreshed and renewed of energy.

You owe it to yourself to relax and enjoy life, you will find with relaxation comes more happiness and satisfaction with everything you do.

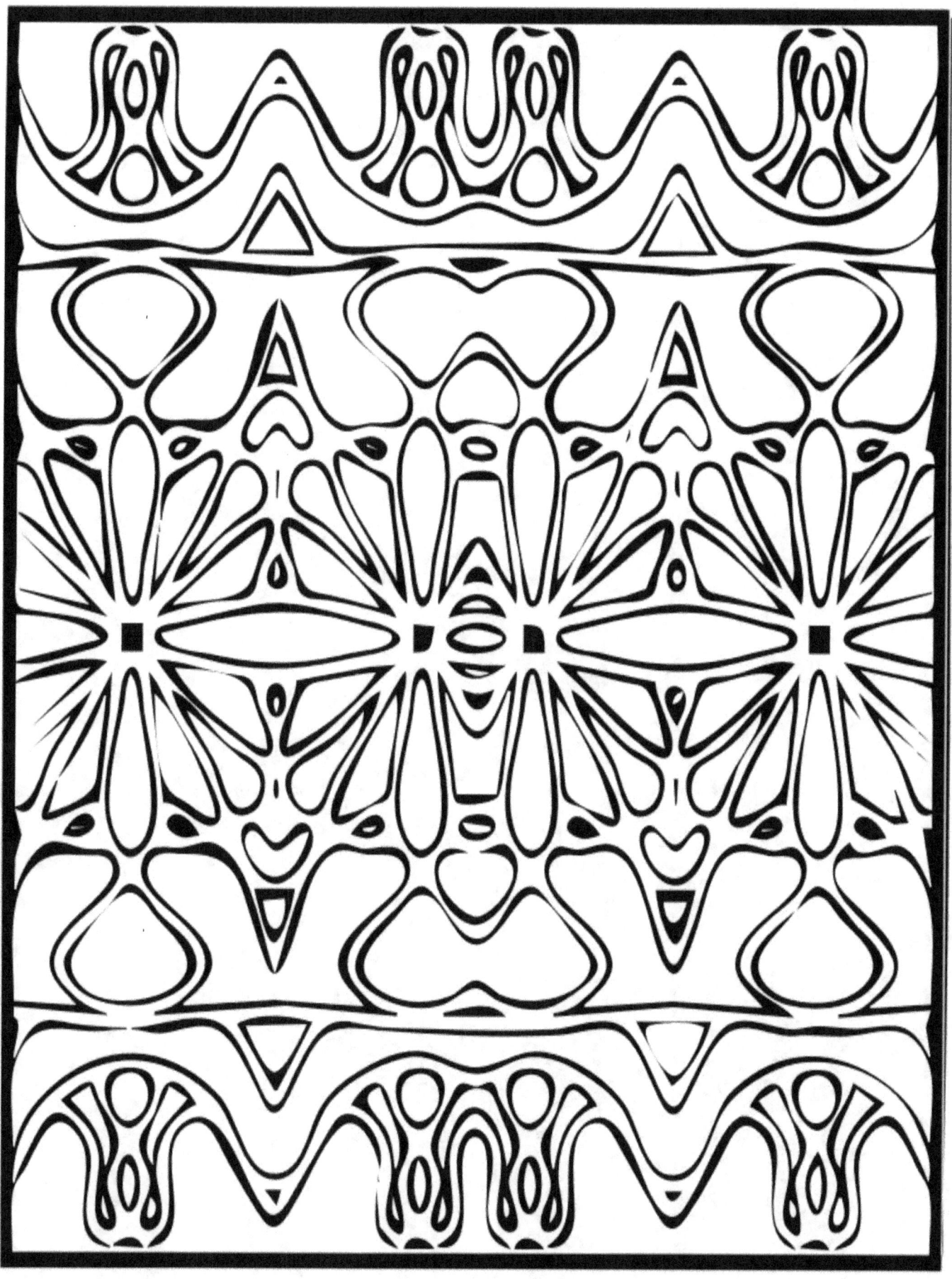

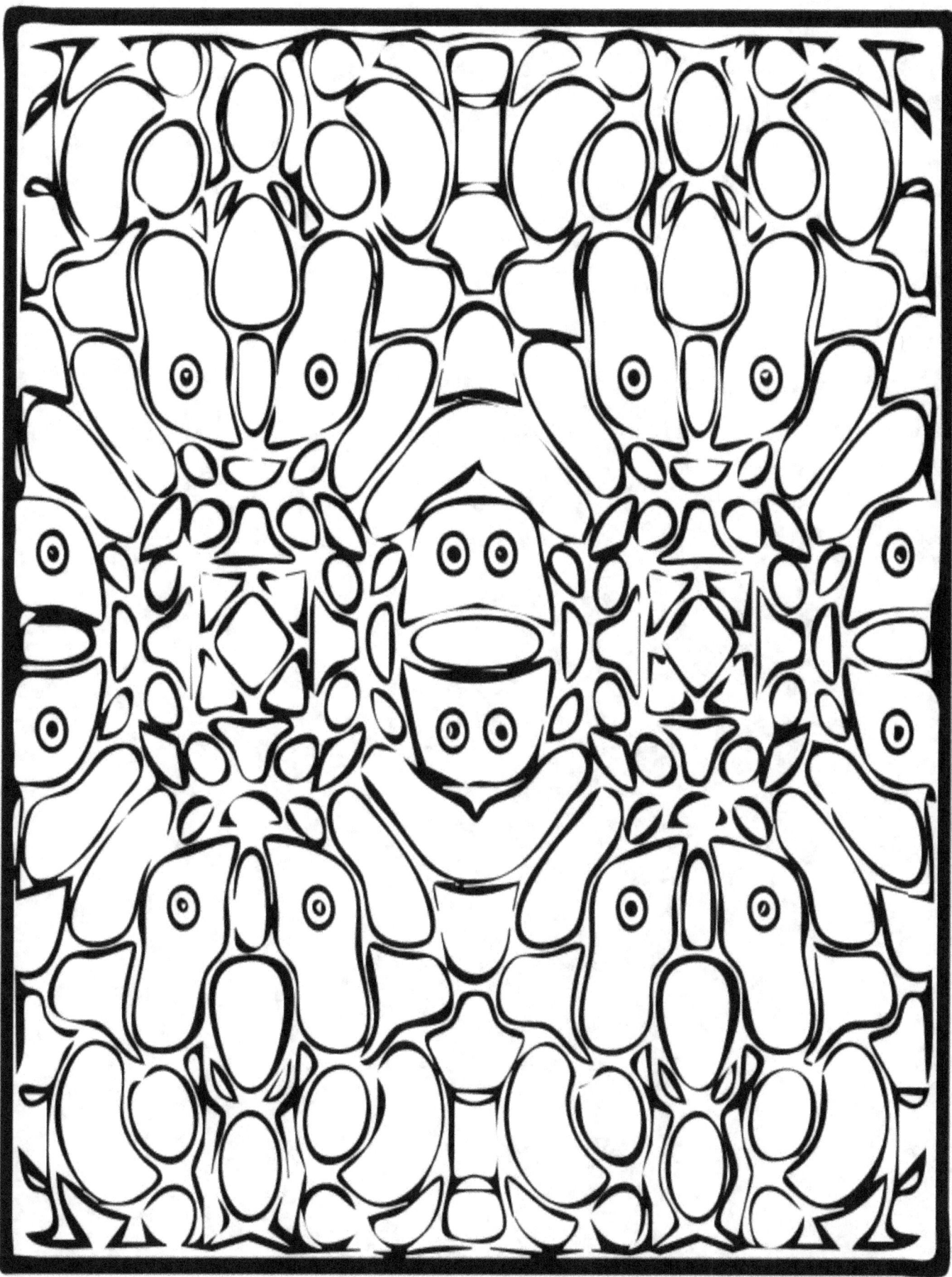

"I believe it is in my nature to dance by virtue of the beat of my heart, the pulse of my blood and the music in my mind."

Robert Fulghum

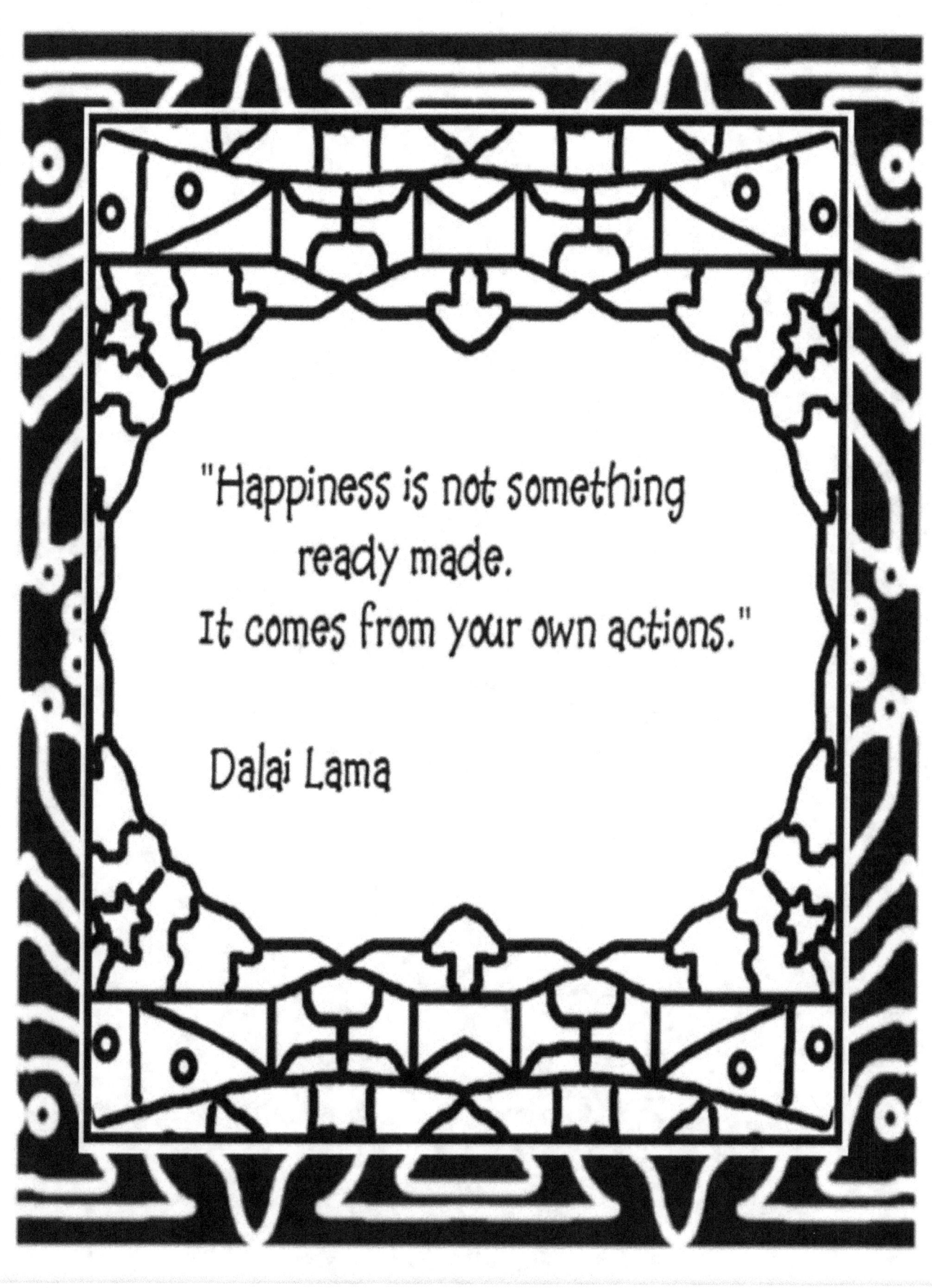

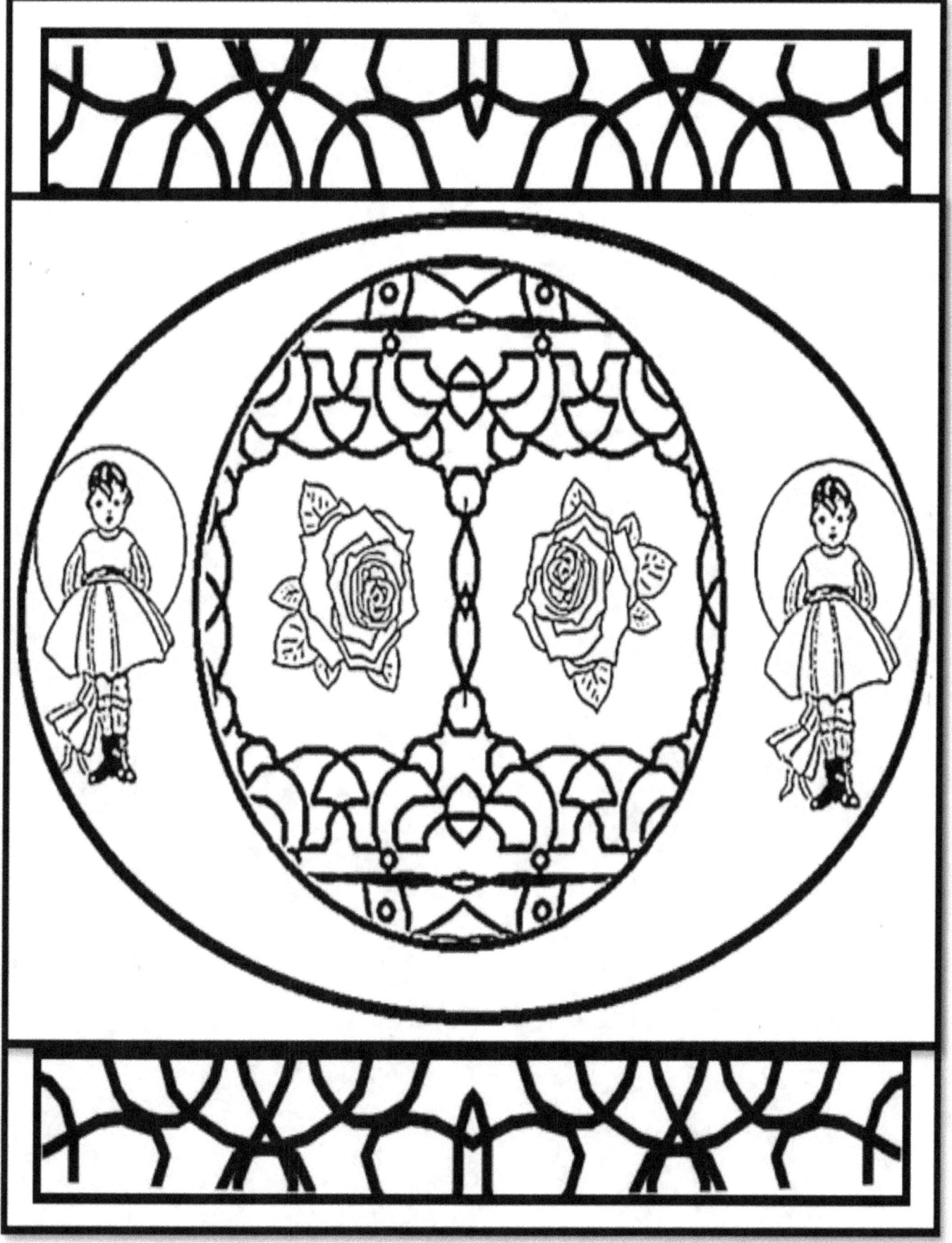

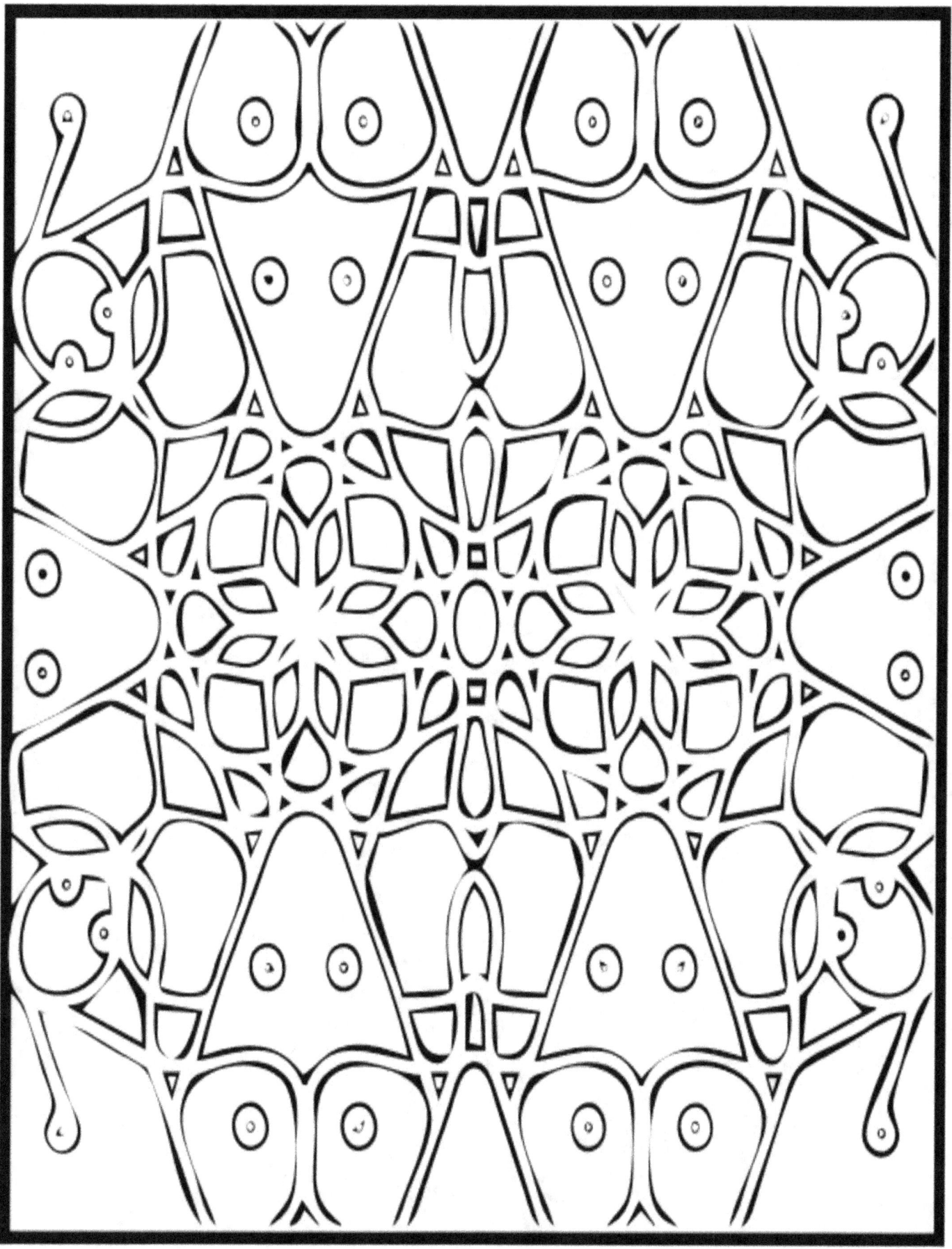

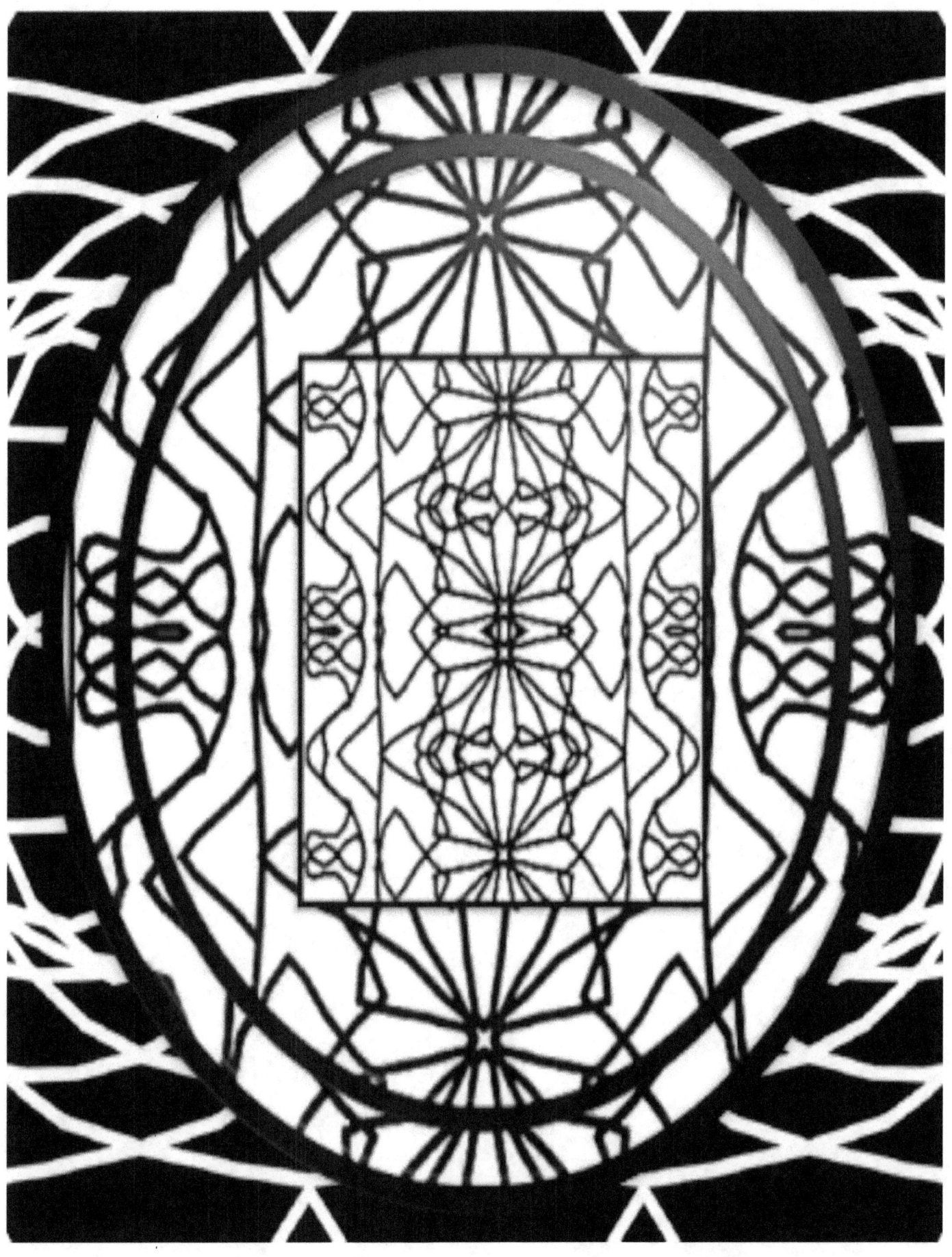

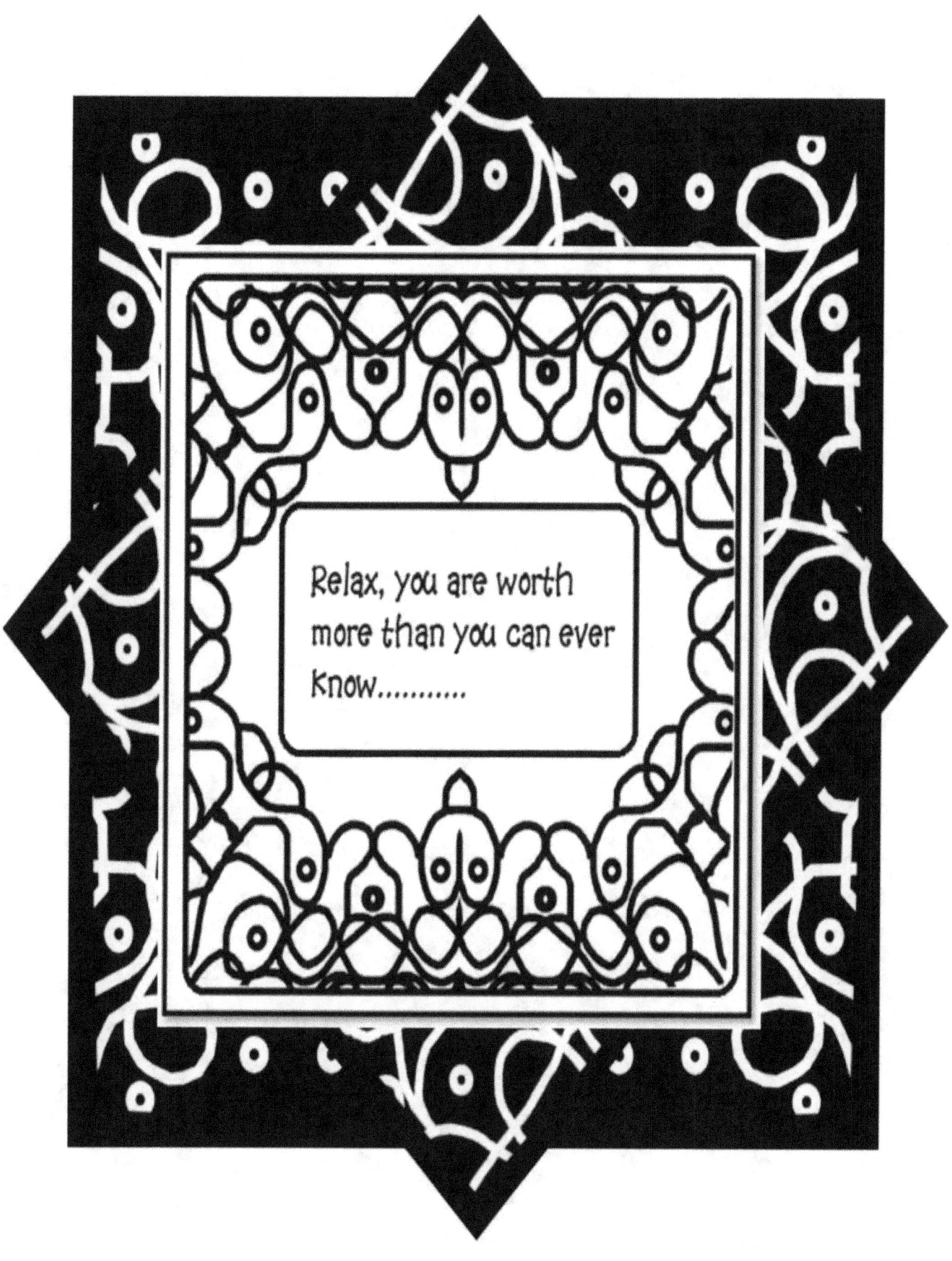

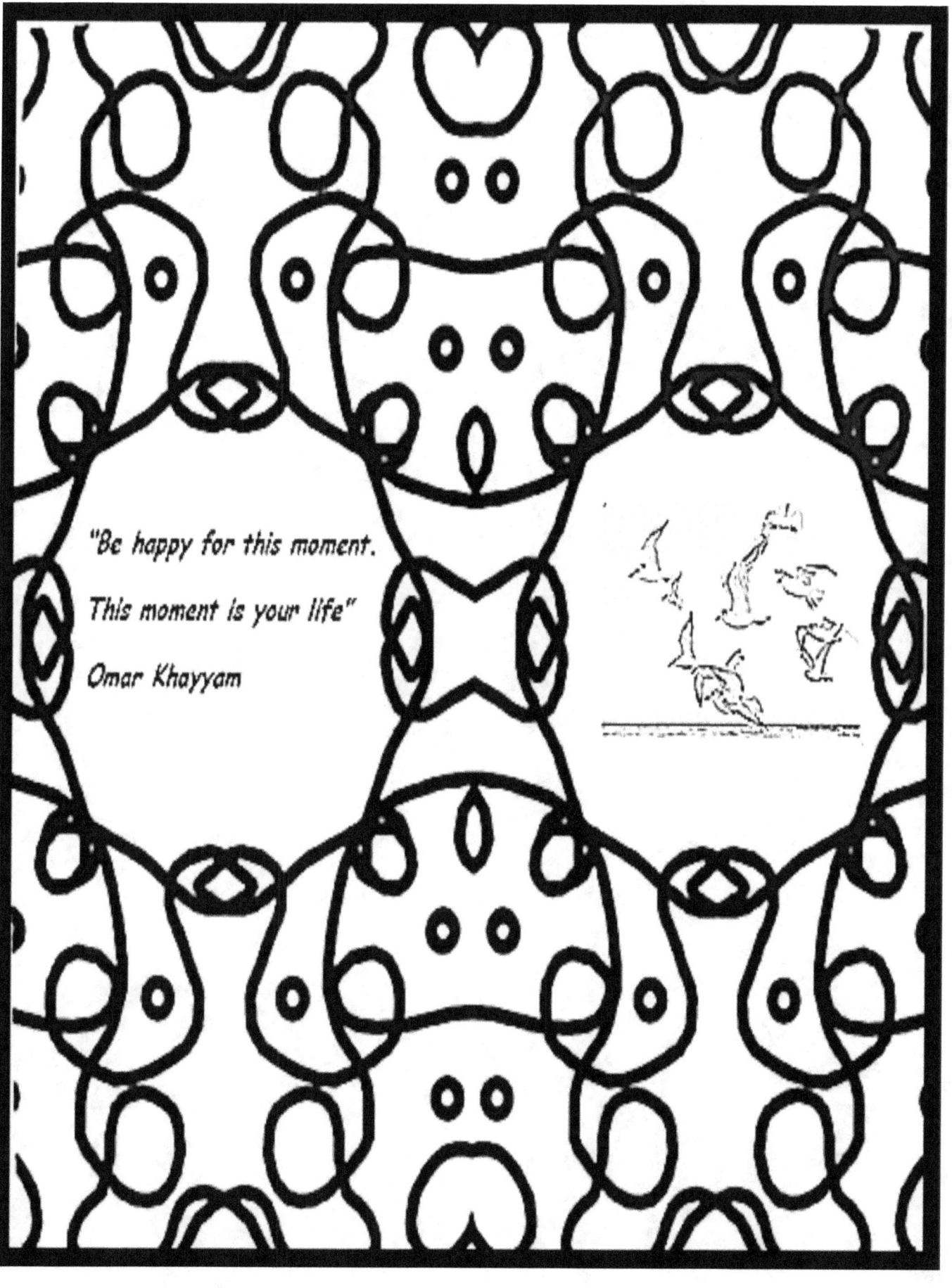

"Be happy for this moment.

This moment is your life"

Omar Khayyam

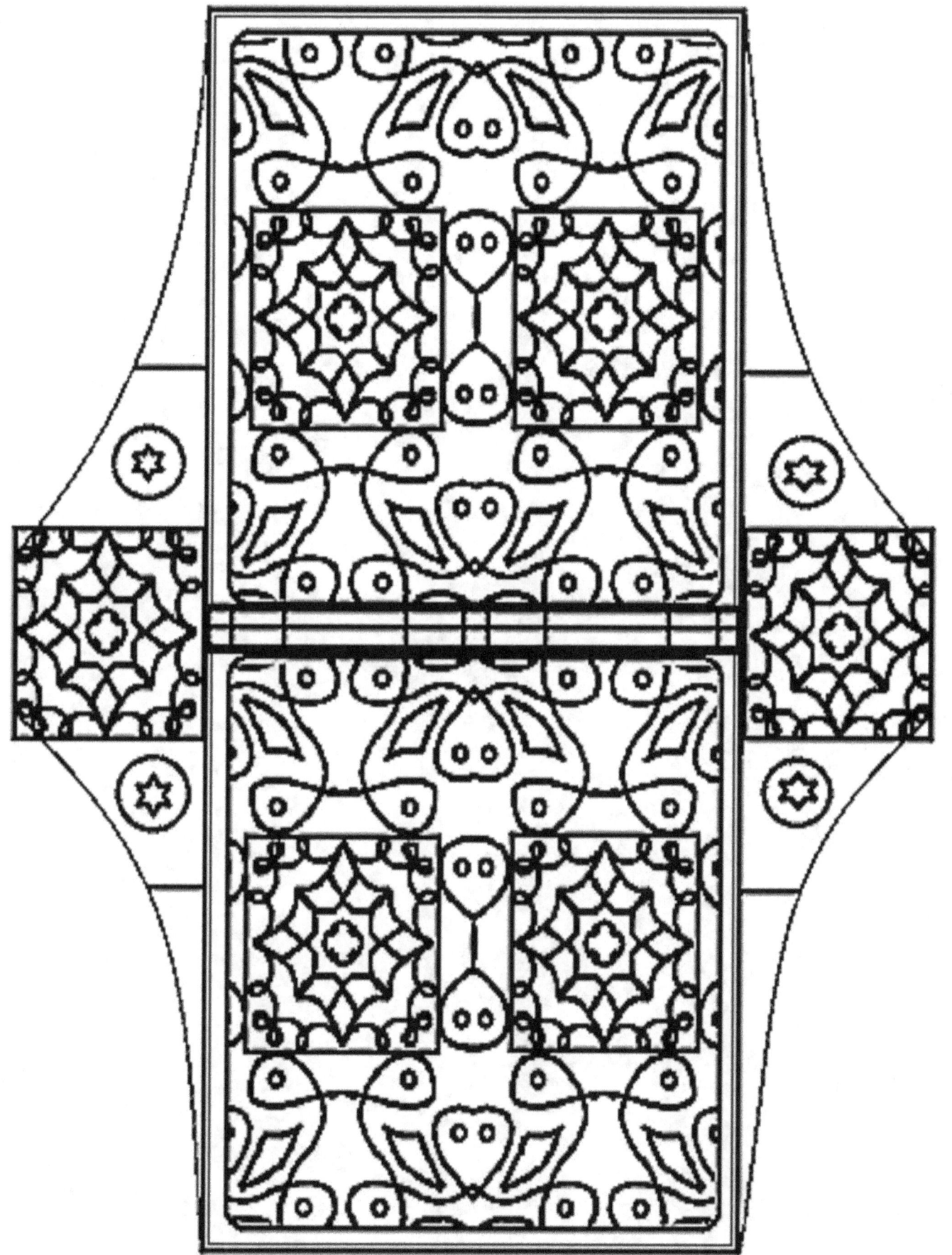

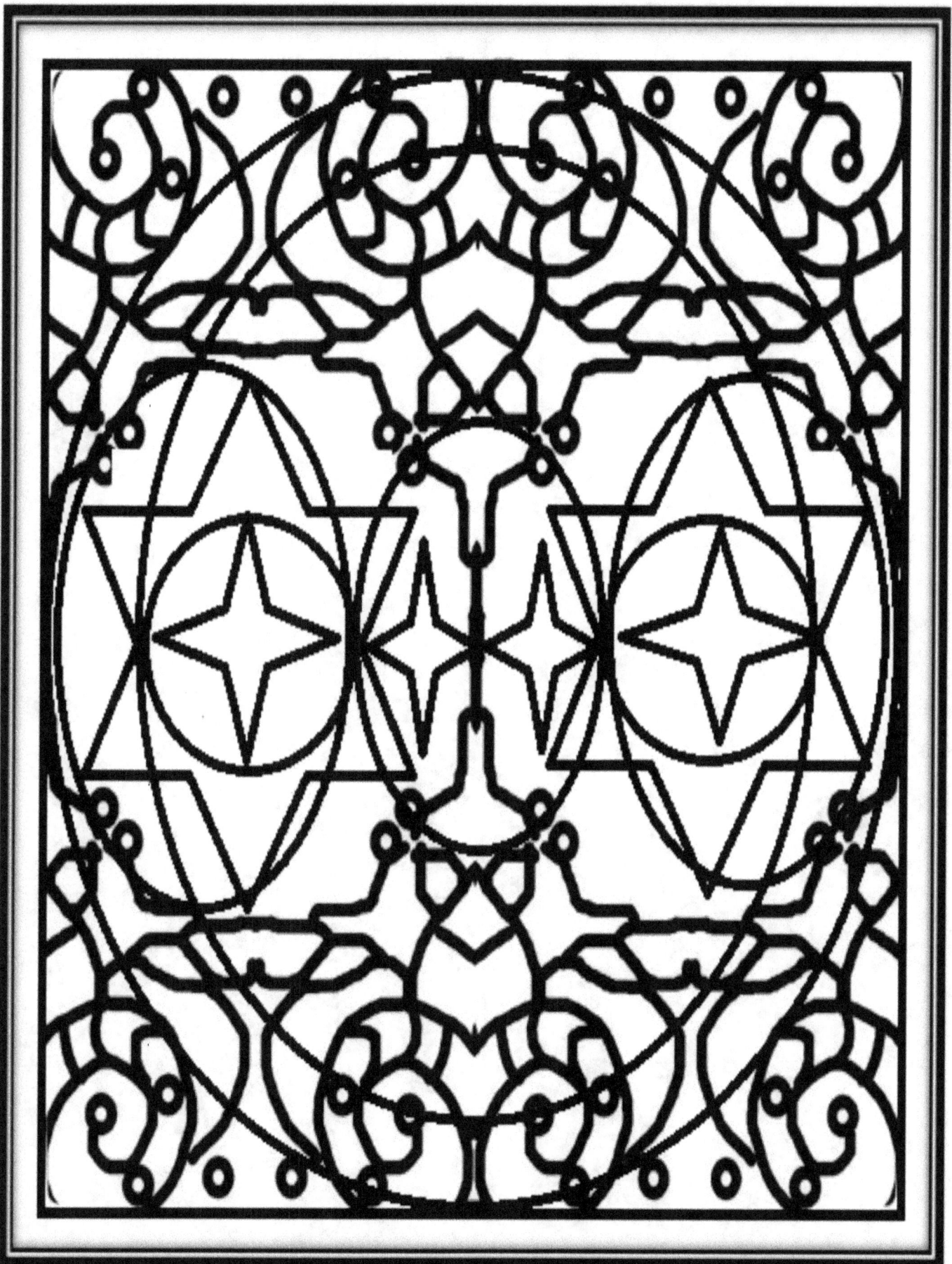

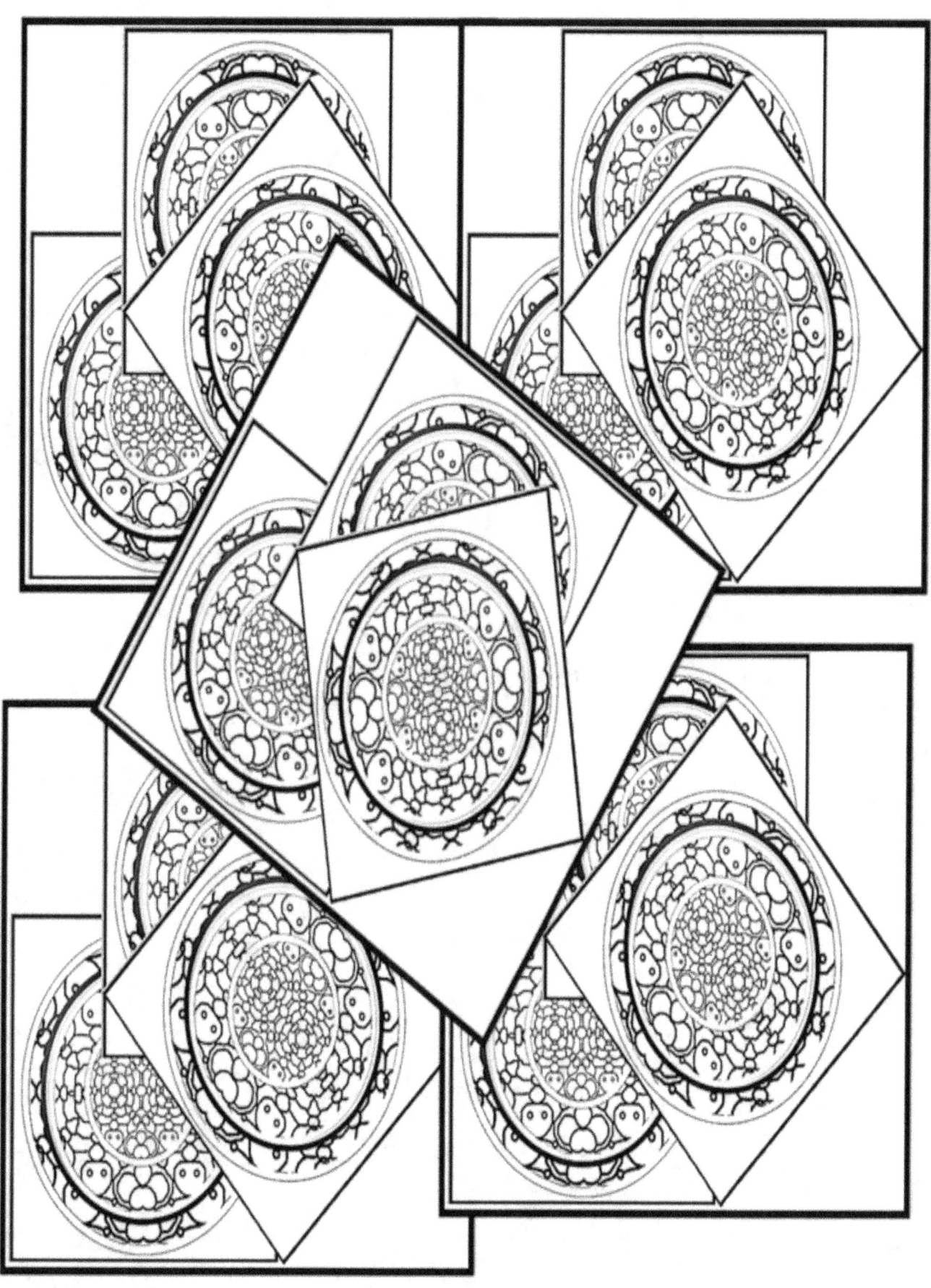

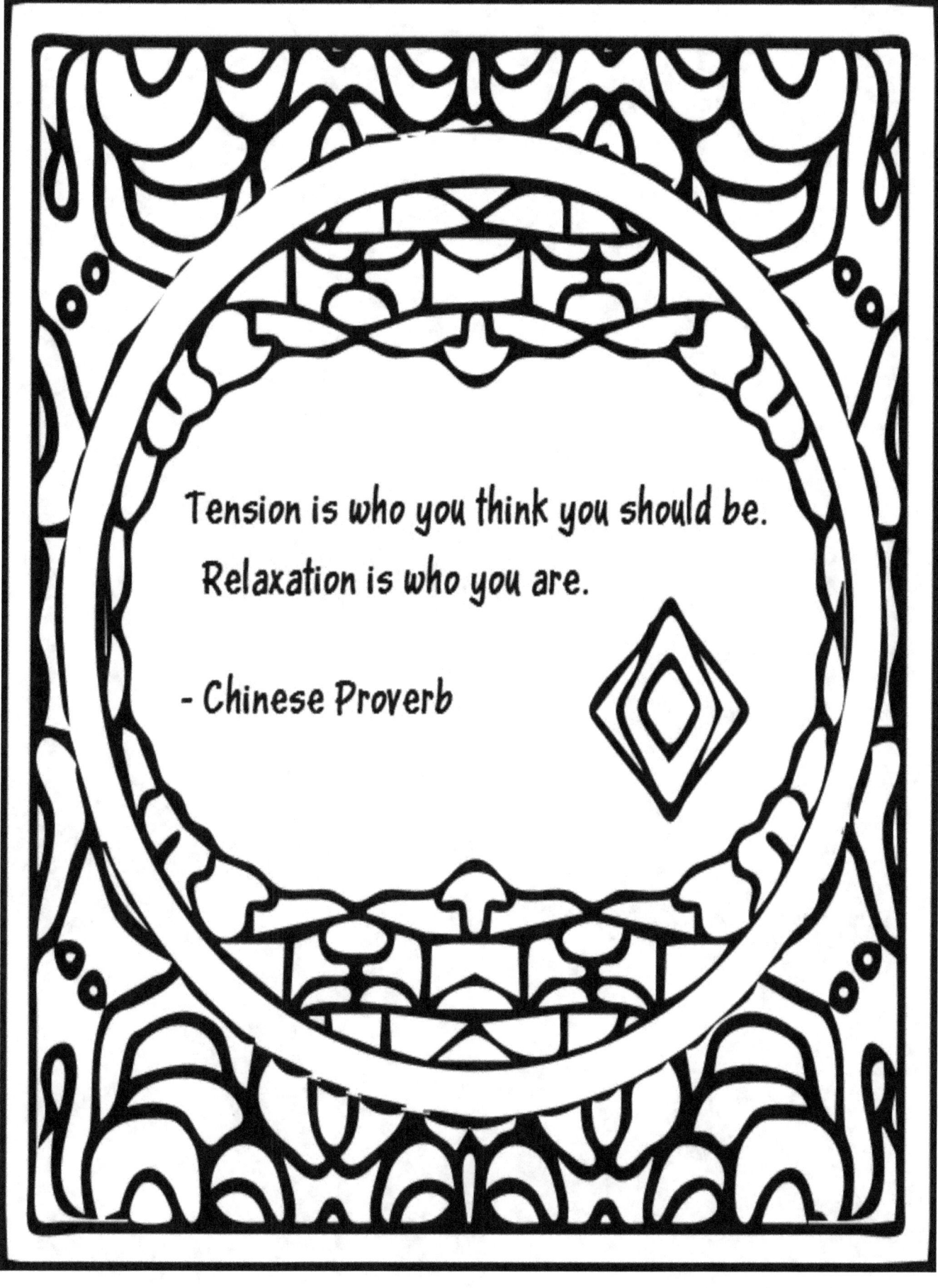

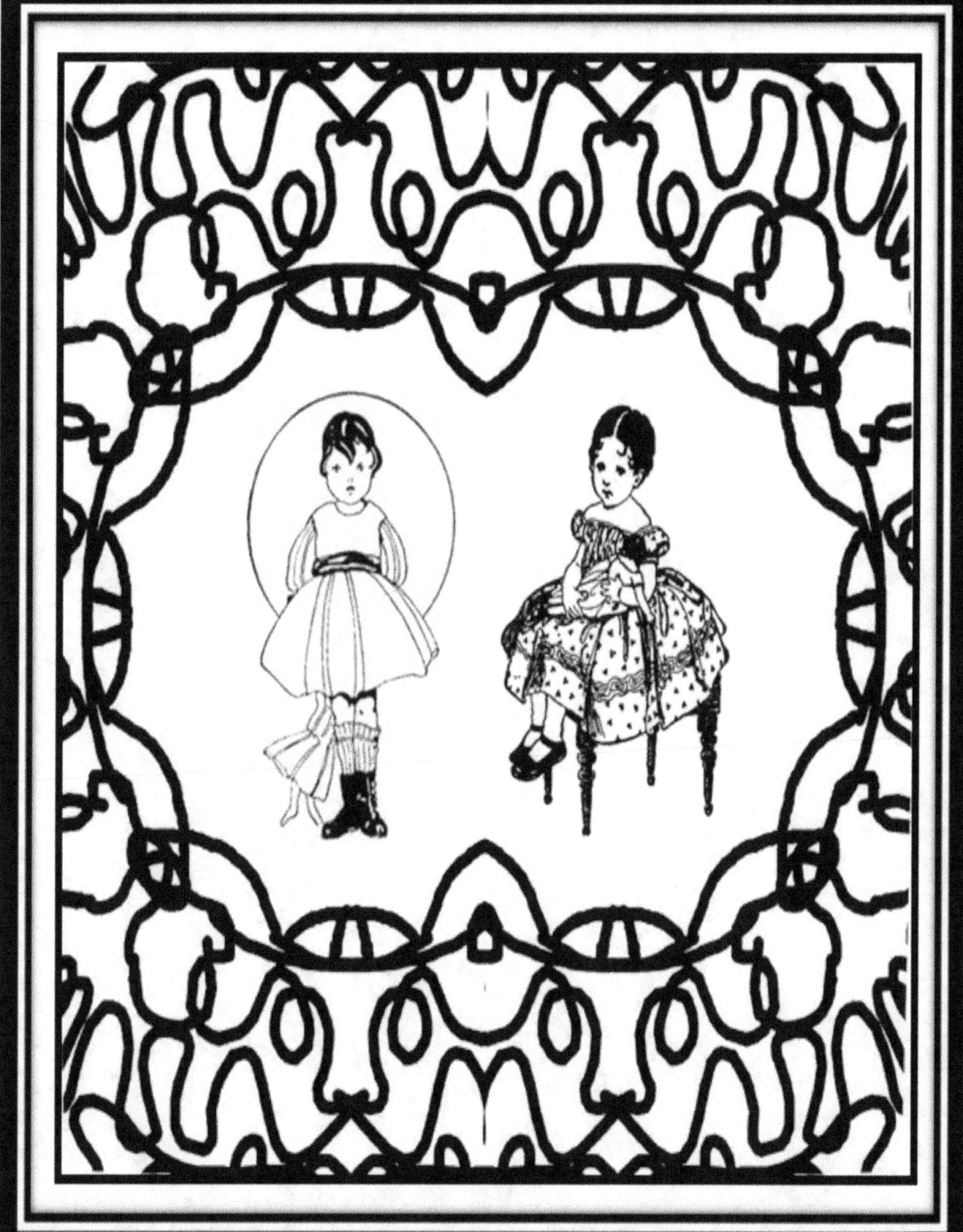

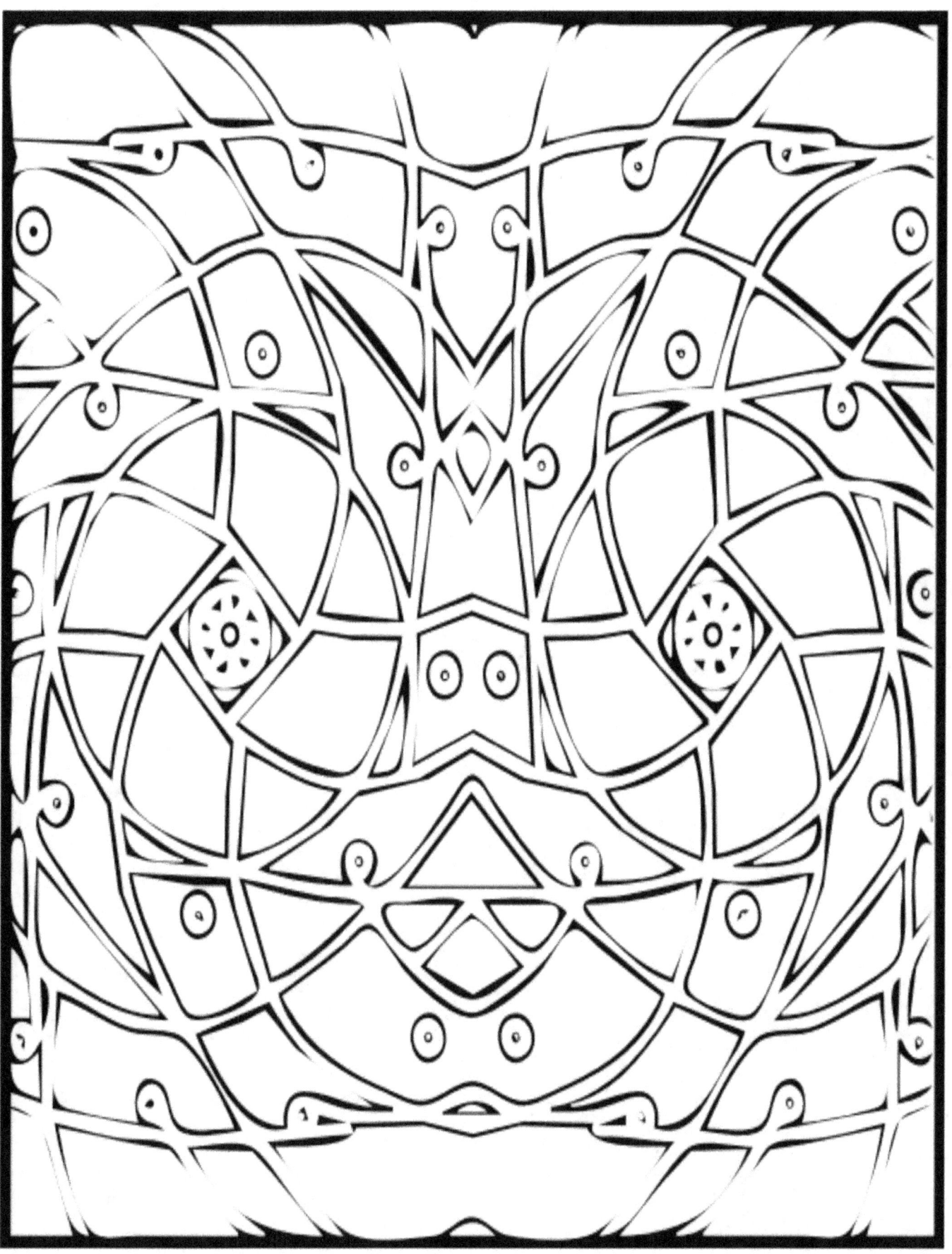

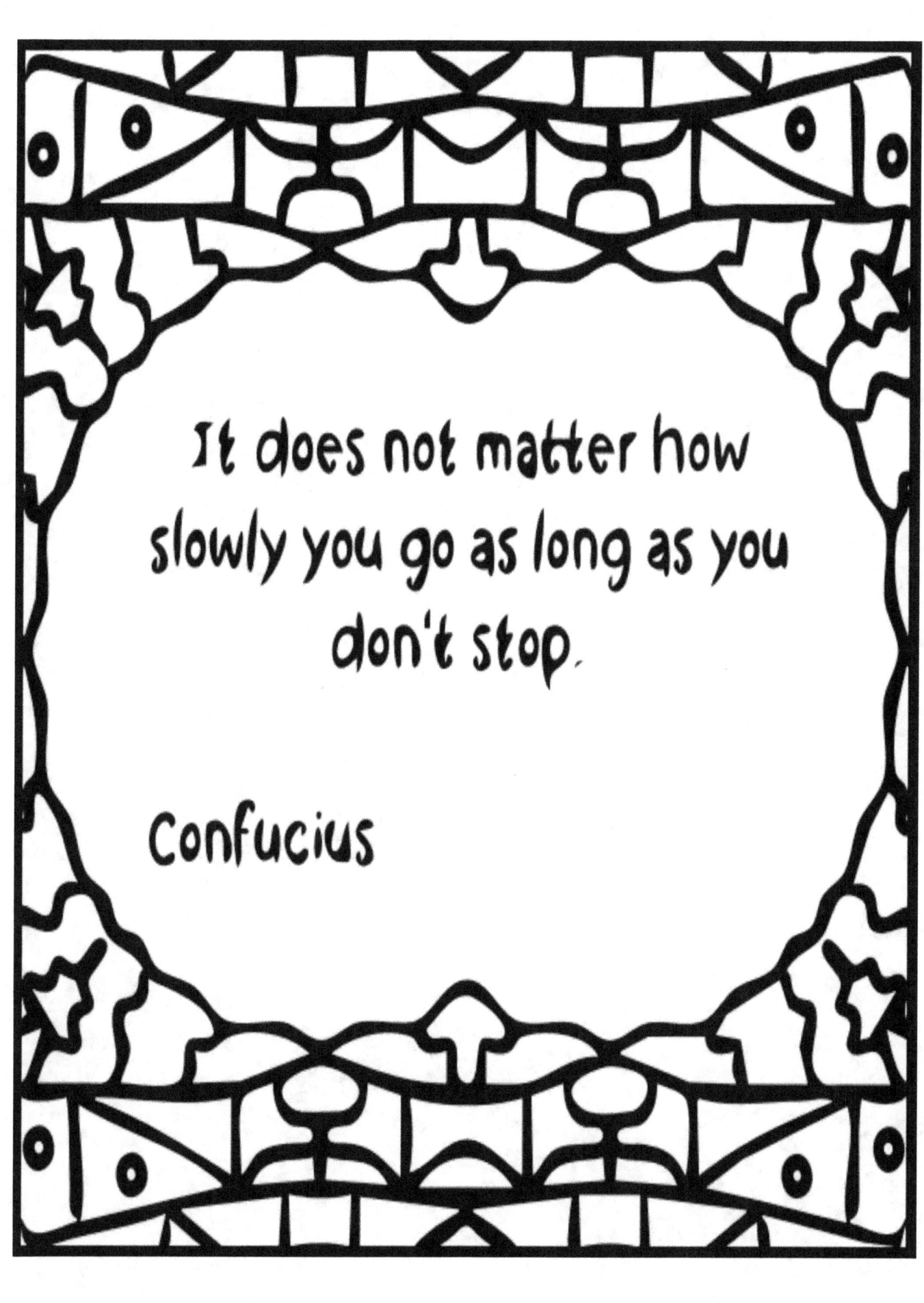

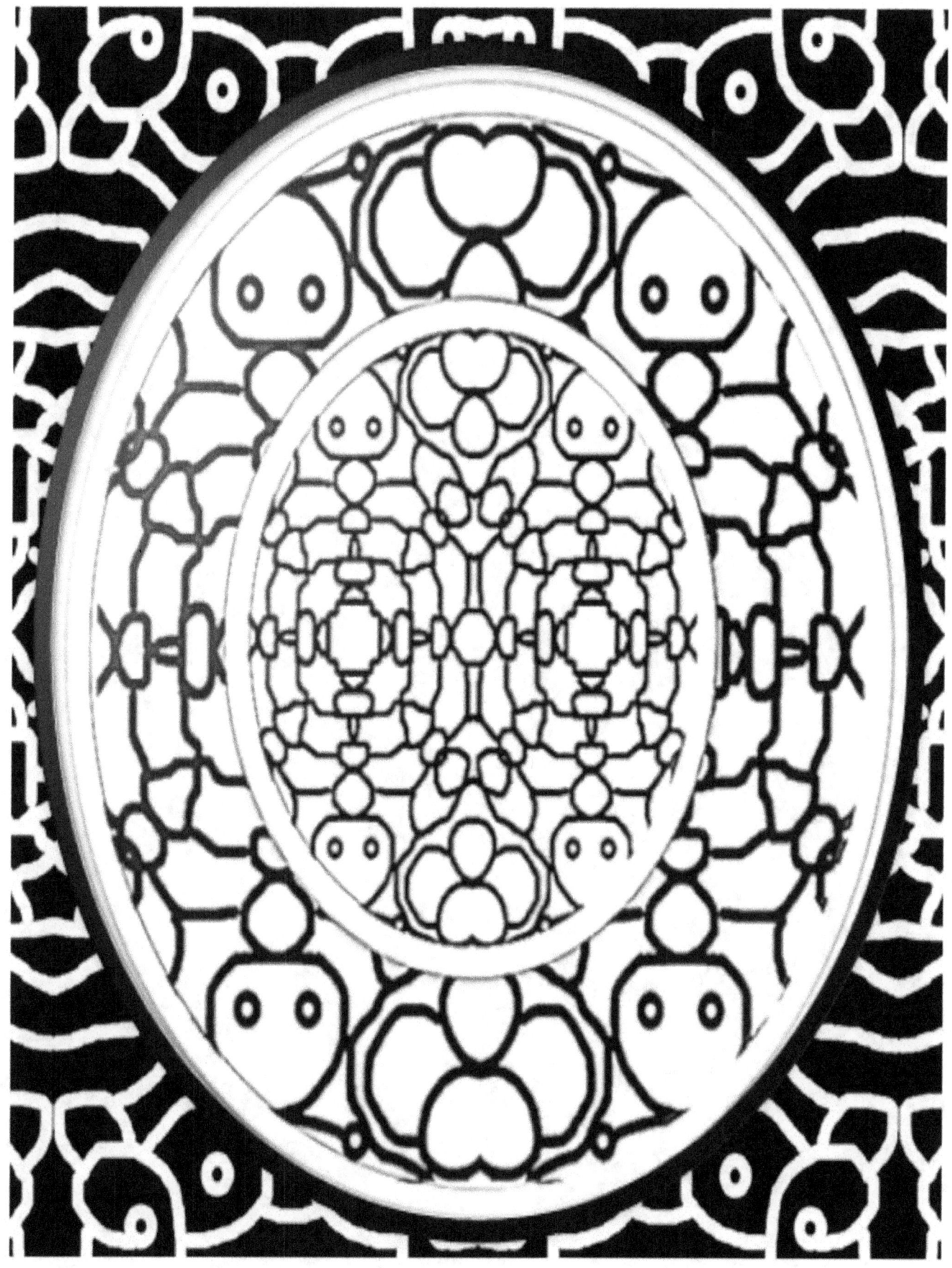

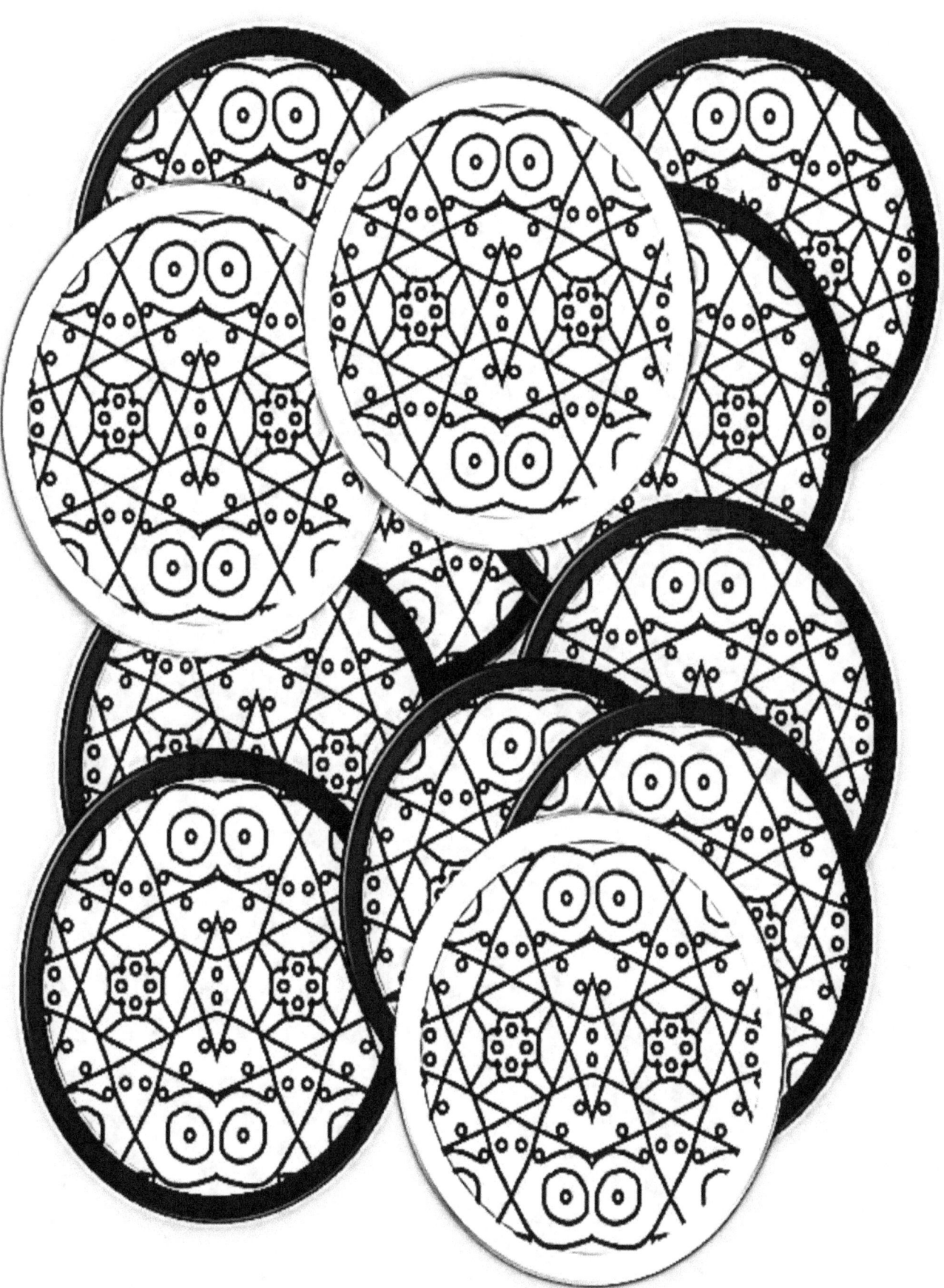

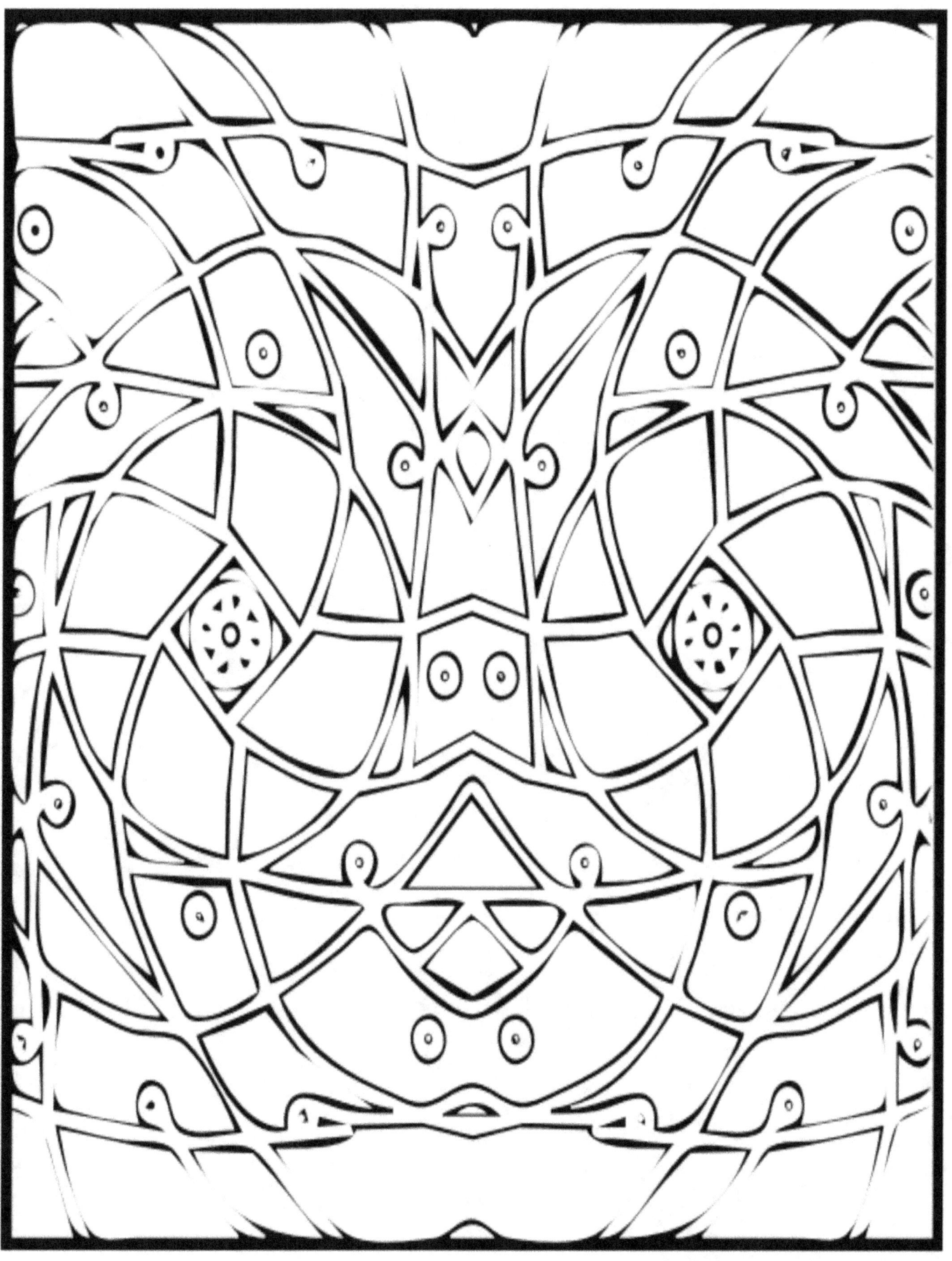

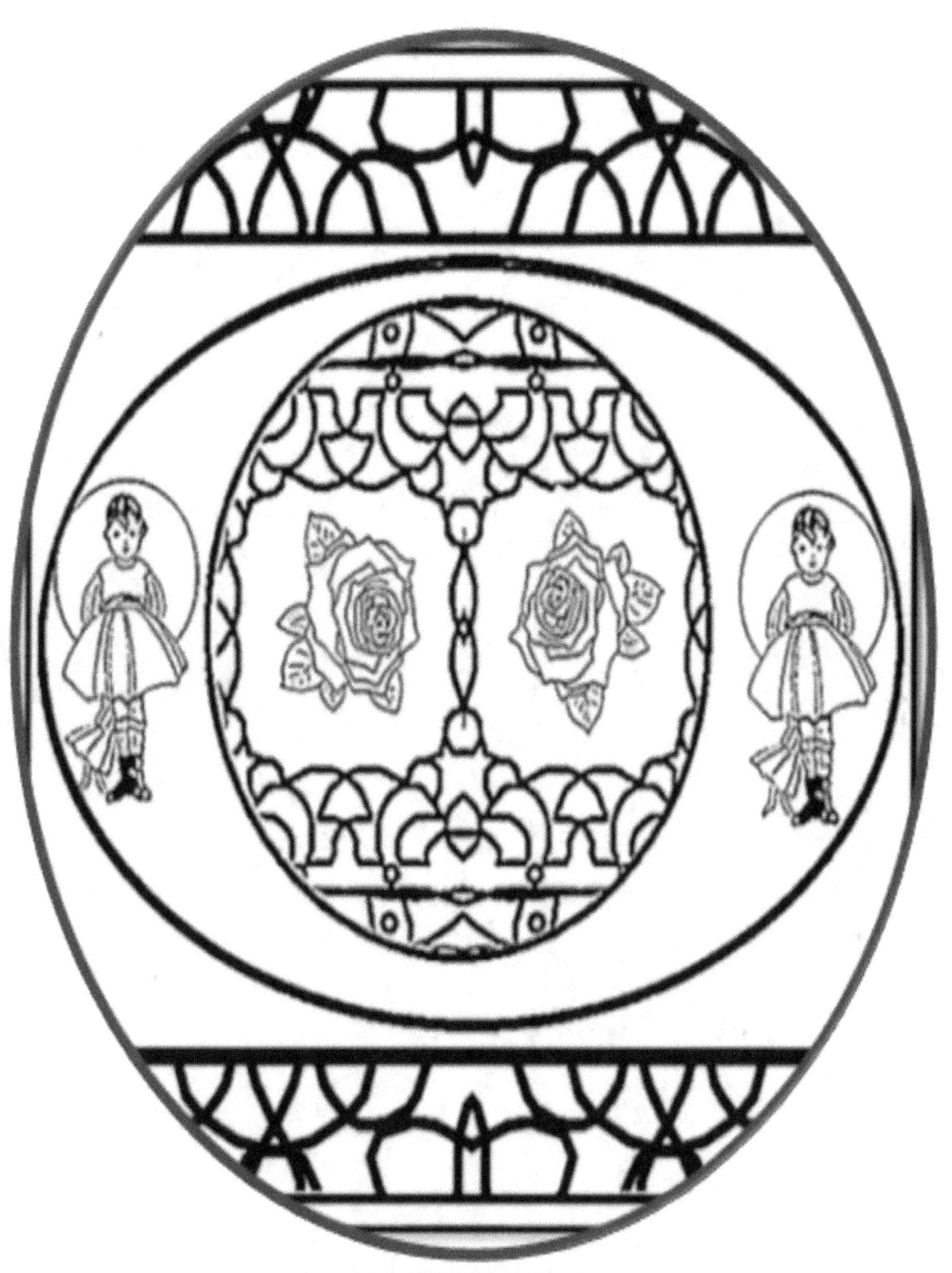

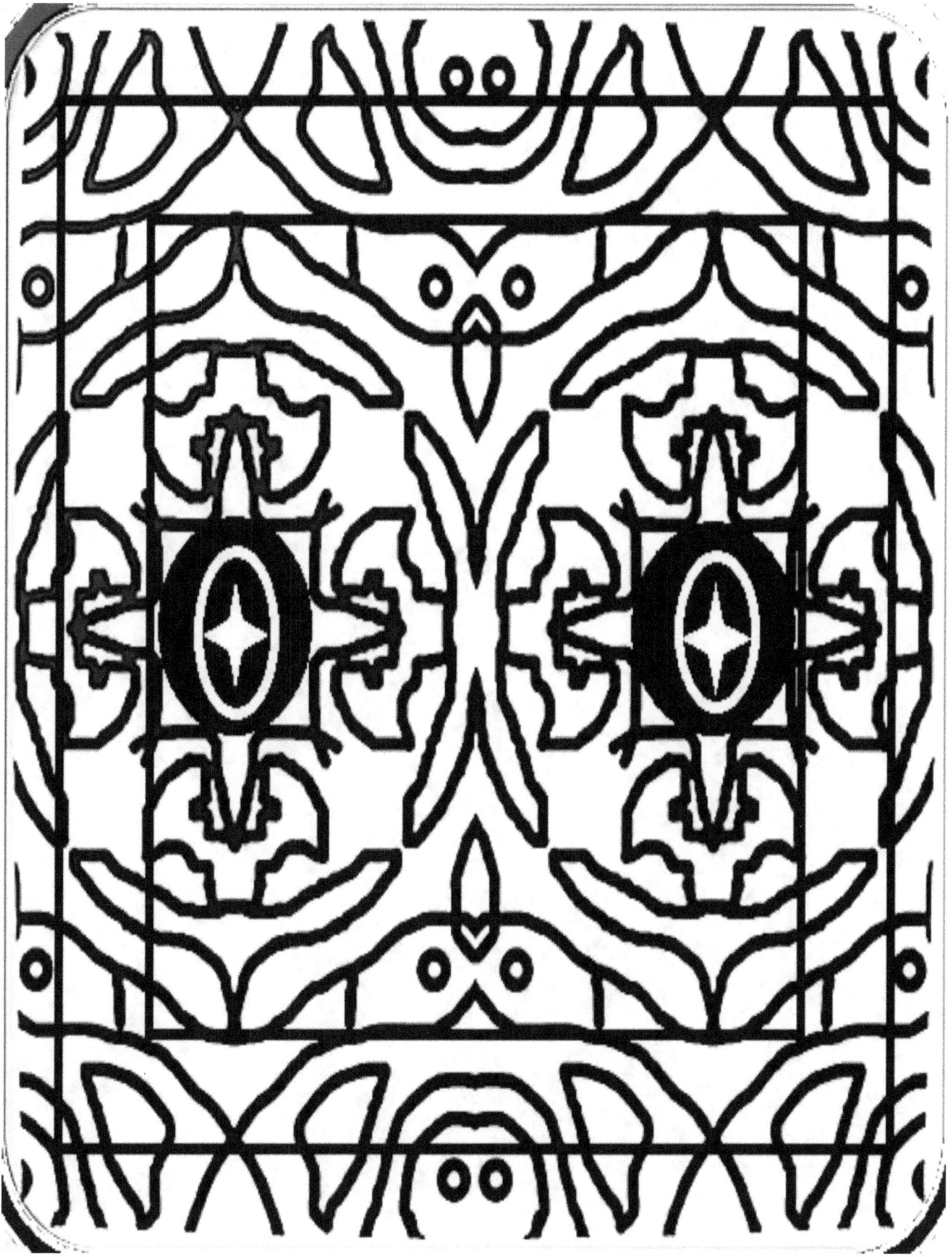

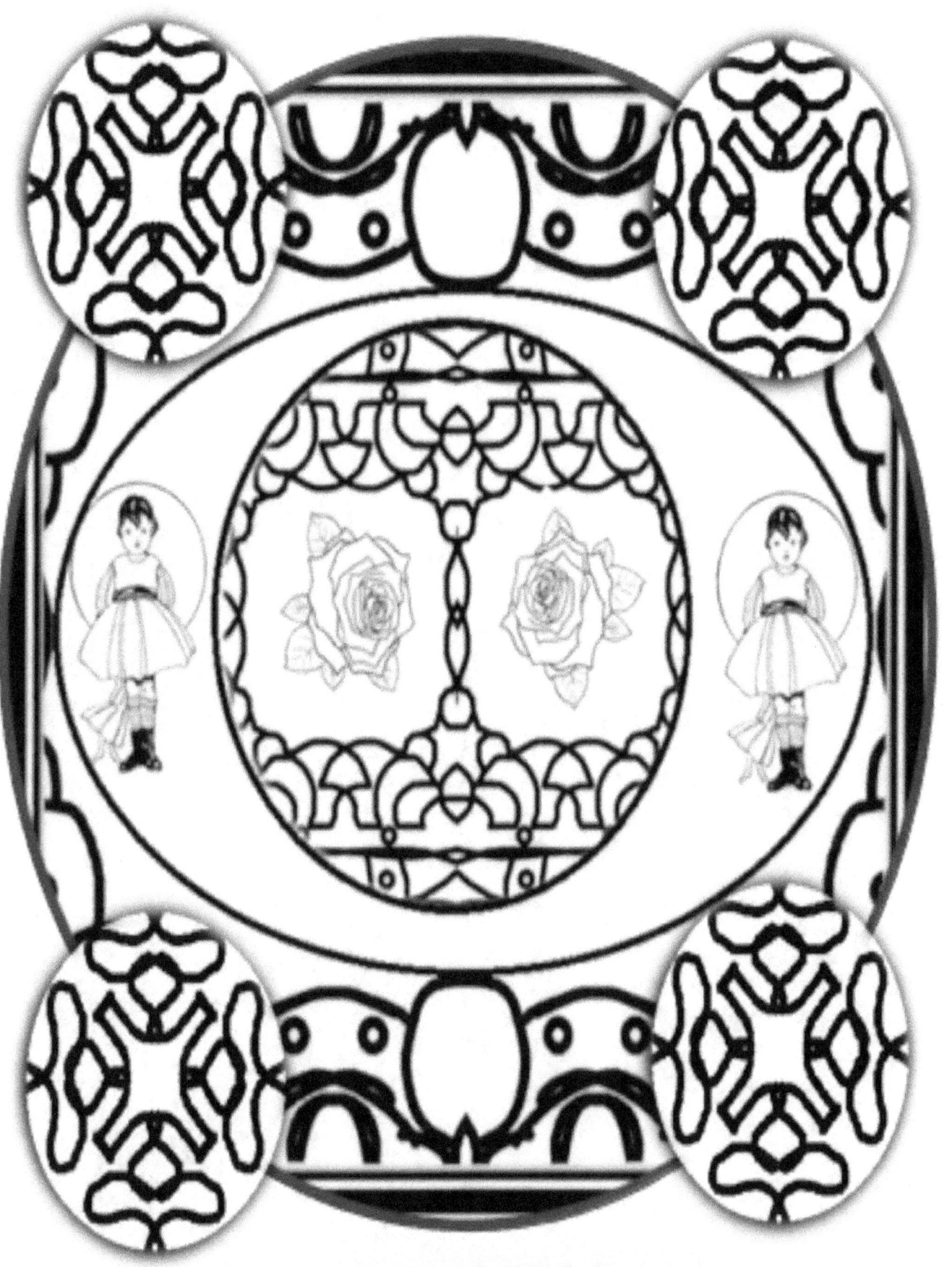